Pagan Holidays of Traditional Beliefs

The Knowledge of Traditions

Lillie Sandridge-Hill

PAGAN HOLIDAYS OF TRADITIONAL BELIEFS
THE KNOWLEDGE OF TRADITIONS

iUniverse books may be ordered through booksellers or by contacting:

iUniverse
1663 Liberty Drive
Bloomington, IN 47403
www.iuniverse.com
844-349-9409

Scriptures are taken from the King James Version of the Bible.

ISBN: 978-1-6632-1864-3 (sc)
ISBN: 978-1-6632-1863-6 (e)

Library of Congress Control Number: 2021903377

Print information available on the last page.

iUniverse rev. date: 02/17/2021

To my dearest siblings,
Mary, Herman, and Billy

Forasmuch then as Christ hath suffered for us in the flesh, arm yourselves likewise with the same mind: for he that hath suffered in the flesh hath ceased from sin; that he no longer should live the rest of his time in the flesh to the lusts of men, but to the will of God

—1Peter 4:1–2

Contents

Preface...xi

Chapter 1 Traditions: A Way of Life...1
Chapter 2 Transgressions of Idolatrous Feast11
Chapter 3 Truth, Not Lies ..19
Chapter 4 Things God Has Asked of Us ..27
Chapter 5 True Believers of God ..35

Conclusion...45
The People of the World (Poem) ...46
References and Research History..47
References..49

Preface

Christmas, Easter, Halloween, and Valentine's Day are among the many holidays and traditions that have been created and practiced by man and that have also been commercialized heavily by man. God did not ask man to celebrate these holidays. These pagan holidays and traditions have been reinforced by the Christian church from ancient Roman rituals and customs of Victorian England. The Bible does not mention that we should celebrate these pagan beliefs. These beliefs were not even celebrated during biblical times. Not only are these pagan holidays, But they are also against the teachings of Jesus. The meaning of these holidays, from the beginning of their inception into society, has created a force of its own—going way beyond the reason (and meaning) for celebrating these days to a wide array of moneymaking endeavors to patronize customs not sanctioned by God.

Take the time to study the history of these holidays that are practiced in our society. The most important thing is not how you feel about this but how God feels about it. Satan and the world can distort these celebrations. But kept in the context of *why* we celebrate these holidays can be uplifting to the spirit of man, of course, but still not sanctioned by God. Each holiday should be kept in the context of the meaning it has to us and why we celebrate this day. But do not say you are honoring God when you won't even follow his Word in your day-to-day living. So much of each holiday has been distorted by Satan and man that each one has become a distortion created by society's whims. When the subject matter is sanctioned by God, there is no distortion or confusion. Keeping each holiday in perspective still does not make it right with

God. He tells us in the Bible what his will is for his children. We are not here to please ourselves but to please God.

It is a sad and confusing reality that our Christian leaders have helped lead the people in this distortion and tradition of pagan beliefs—to the point that we the people believe that this is OK by God and that he wants us to celebrate these pagan holidays of traditional belief. No, it is not OK. Please study your Bible, for Jesus Christ spoke of the traditions people keep and asked, why do we keep them? Nowhere in the scripture does God tell us to celebrate Christmas or Easter or any of the pagan holidays that have grown in favor over the centuries—holidays that have transgressed against the commandments of God.

We should not apply these beliefs to the worship of God. Do not take heathen customs and try to honor God, because he is not honored by them. You cannot mix the profane with the holy. Ye cannot drink the cup of the Lord, and the cup of devils: ye cannot be partakers of the Lord's Table and of the table of devils" (1 Corinthians 10:21). No one likes to stick out like a sore thumb. But what is more important to you—your eternal resting place for your soul or how you look to the people who you will be traveling down the wrong path with you to your demise? It's down to your choices or God's will. Every day in our lives, we make choices that we have to live with. Or we can make changes for the betterment of our well-being.

"And have no fellowship with the unfruitful works of darkness, but rather reprove them" (Ephesians 5:11). Every day we live is accountable to God. What will your answer be if God is to ask you, "Why did you celebrate these days?" Will you reply that you did so because everyone else did? Will you say, "I'm sorry I never read the true teachings of your Word".

But he answered and said, every plant, which my heavenly Father hath not planted shall be rooted up. Let them alone: they be blind leaders of the blind. And if the blind lead the blind, both shall fall into the ditch. (Matthew 15:13–14)

In my book I will give you two points of view. Make your own decision on what path you shall follow.

Chapter 1

Traditions: A Way of Life

I do believe that God does not care how devoutly religious you are or that you go to church every Sunday. But he wants his children to believe, trust, and have faith in him. He wants us to do the thing asked of us, not follow our pagan traditions. We all grew up on the traditions we celebrated each year, with fond memories of family and friends getting together to celebrate each occasion. What we have not questioned is where do all of these holidays and traditions stem from? Why do these things religiously every season but not do as God has asked each and every one of us to do in our daily lives among one another? Our traditions have become a way of life, and we don't question whether this is what God wants or what we want. Traditions are fruitful in bringing people together for happiness and cheer among family and friends during the year, but God's commands will keep us close in hearts and minds daily, not just at certain times of the year. Do unto others as you would have them do unto you on a daily basis, and you will feel the truelove of our Savior. The traditions we celebrate each season are based on pagan beginnings and have flourished with added pagan beliefs during the centuries, which, has only compounded our traditions to a commercialized effect for the have and have-nots. God is not impressed with our traditions but only with knowing that his children are following his Word in true belief and faith in him and what he expects of us.

When you celebrate your yearly traditions, do not place God at the head of a day that he has not asked of you. Place God at the head of each new day you begin so that each day will began with the strength of God at your side. Follow his Word daily, and he will be honored daily. I know traditions have become a way of life that grows comfortable with each passing season. Are we like sheep being led to slaughter? Or can we open our eyes and see the simplicity in God's Word and follow in faith of what he wants for his children. Looking at both sides of the coin can give you two choices in life, but only one side will give you eternal bliss.

Life on earth is short, very short. Choose wisely. Traditions do become a way of life that can have a choke hold on our faith, trust, and beliefs in this world. We all can get bogged down with traditions, not knowing the extent of our own deceptions, for we have been given so much rope to hang ourselves with that we feel free, when we only have the illusion of freedom that ends at the end of the rope. God does not like to be honored with our mouths and not with our hearts. The different holidays were authored not by God, but by men. When seeking out our Savior's will, the most important thing is not how you feel about it; the important thing is how God feels about it. It is vain of us to give honor to him if he does not see it as honoring him in this way.

Our way of life is what we know best. What we know and believe in is a daily compass, guiding how we live our lives on earth; we follow what we believe to be the normal sequence of each day, month, and season, constantly thriving to survive as the basis of our existence. Our way of life is all we know to be true and to challenge that belief will stir emotions that will lead you to question what you've been taught all your life. As always, to rock the boat is scary. But doing so can bring insight. It can reveal the possibilities that arise when what you've always taken for granted to be the way of the world we live in—the way we as people who thrive to survive should live in it—are challenged.

While growing up in this world, we follow the way of life that is presented to us by our parents, never questioning anything. They lead in the direction we feel is safe and good because they and others say this is what we do at these times each year. So growing up in tradition becomes a way of life that is acceptable and unquestioned if you want to fit in and feel the sense of normalcy that comes with living your life to

match others who you live alongside each day of your existence. This is a normal feeling. But is this right because this is what you were taught? Or is this what God has asked of you as his child to follow to reach eternal life in heaven, in a place that he has prepared for you among the many rooms his house has for his children?

I personally have not read in the Bible where God has asked us to honor him by celebrating the holidays we celebrate each year. Each holiday is set with only the desires of human beings. The way of thinking behind each suggests that this will honor God or some other entity we have created to celebrate or honor for our own satisfactions. Sometimes, as a people, we do things as a tradition, not based on truth or religious beliefs but, rather, just plain old way of life. We follow the paths of our ancestors because this is what we do without question.

I am not condemning anyone who celebrates these holidays throughout the seasons. Just please recognize the pagan elements that exist in these celebrations. Do not let your way of life become the albatross of your demise when it comes to living your life as your Savior wants you to. Think simplistic and clean, above all the well-being for all human life. Our religious leaders should be teaching us the truth, not long-carried-out traditions that have been passed down through the centuries that are not based on the teaching of Jesus. A lot of things are done to satisfy the masses, but satisfaction should be based on God's Word, for God's Word is what shall set us free of bondage from Satan's grip on the world as we know it to be. When I study the Bible I see no complications in what God has asked of me, just my own human desire to follow the masses and not just let go. We become so programmed to our way of living that we cannot or will not let go of a lie that has a choke hold on us as children of God.

Ask yourself a question and answer truthfully. Do you believe that traditions are a way of honoring our Father in heaven on those special days or a way of life that you have become accustomed to celebrating? When we honor God, we do not imitate pagan ways of living to celebrate him. Our traditions have crippled us and left us believing in a way of life that is not sanctioned by God. We have been celebrating pagan holidays for centuries now and following the lead from our religious leaders. Some leaders know the truth and lead the people in the right direction,

and some just keep on leading their sheep to slaughter. Our lives have become so commercialized that, without these holidays to sell to the public, we would lose a great deal of commerce throughout the year.

We should celebrate one another daily and honor God constantly in our lives by obeying him. To honor someone is to show respect. What I'm saying is that you can honor and celebrate every day of the year, not just on a special day. Showing your love for God and just for one another should be done daily. Our way of life should reflect our beliefs in what the Bible teaches us, not pagan rituals passed down through the centuries and not sanctioned by God. When we follow the steps that God has taught us in the Bible, there is no confusion, just a clear path that is not compromised by pagan beliefs that satisfy the many people who want to celebrate something to satisfy them not God.

We should take the time to understand what and why we celebrate on these days. How did these holidays come about? Did God ask you to celebrate these days? What is the purpose of setting aside a special day? Why not show your love for God and others every day with a kind word, a helping hand, or just a courteous gesture of kindness? Have you noticed how people are so nice to one another around the holidays and then go back to their selfish, curt, gossipy ways soon after? Why don't we just keep it simple and be nice to one another every day, for I believe this will honor our Father more than the fake sentiment covered in sparkling lights that has become a way of life for some.

The holidays we celebrate are just an invention of man that has grown in a way that our lives have become commercialized to buy, buy, and buy. Should we walk in these customs that are rooted in pagan idolatrous ways? No. For the love of God, we should examine our beliefs to see if they are in line with the teachings of our Savior. We the people have learned the way of the heathen and made it a traditional way of life. When you examine the truth by doing your research, you will see the beginning of the road you were led down. You will see how each generation has followed the deception, thinking they are honoring God. To honor God or anyone you love is a daily blessing that we should bestow upon one another and that cannot be commercialized. Traditions belong to men. Honor God by doing as he has asked of you.

For my lifestyle, keeping it simple has been more rewarding, less stressful, and more gratifying in all respects of my health, happiness, and well-being. And it has taken me a long time to come to this conclusion. The day I changed my lifestyle and started living the way God expected me to, things became much more manageable. When I changed my way of thinking, living, working, and socializing with others, my life became less complicated. I still hope for the best, but I watch out for the worst.

All the pagan holidays created by man have done is given people false hopes, dreams, and beliefs. Why not live a daily life of giving and receiving a kind word, a nice gesture, and a small gift bought or made from the heart? Why do we need special days? All days should be treated as special. We have created our way of life in order to satisfy a need that cannot be quenched by sparkly desires that flee as quickly as a falling star in the sky. Ancient pagan beliefs and satanic rituals are still being honored today. A society that supposedly has grown more educated and less barbaric remains unaware of the way God wants his children to live. Do not embrace the deception that surrounds you. I ask you to research the meaning and beginnings of each holiday and study your Bible to see what God has asked you to honor in his name. I know paganism and Christianity have become almost indistinguishable, but the deception will only appease the vain in heart.

All deceptions come with failed promises of false dreams of things that aren't built on truth or honor. Our way of life should show obedience to our creator, not demons. Our traditions have flourished throughout our society for centuries, grounding these pagan beliefs so that they have a stronghold on God's children. God is not honored by our pagan beliefs, but by our faithfulness in honoring his Word.

How simple to see the paganism in Santa Clause, the Easter Bunny, and things that connect us to witches and demons on the dark side of life. And let's not forget Valentine's Day, for almost all holidays can be traced to pagan roots. When you celebrate these and many other holidays rooted in pagan beliefs, you are perpetuating a false and deceiving lie that has spread in many variations throughout the world, with consequences for all.

The worldly way of living will come to an end someday, but the Word of God is everlasting and true to the followers of true faith in our

Lord and Savior. We all want what is best for ourselves and our children. And God knows this. That is why he is the truth, the way, and the light to guide us through the darkness and false perceptions that we encounter each and every day of our way of life—deceptions that take us down many roads in our lifetime. Deception is around every corner in this world. That is why God has shined his light upon us, enabling us to see our way through the darkness, haze, and mazes of living. Take heed to God's Word, for he is only trying to show his children the true path that we should take in life.

Most people are so entrenched in their traditions and way of life that it would take a personal visit from Jesus to convince them of what our heavenly Father has asked of us to do. And even then, some would still deny the truth. When our Savior walked the earth in the first century, he didn't seem to take a liking to tradition. Consider his response to the scribes and Pharisees (Matthew15:1). We must ask ourselves, is what we do pleasing to God or pleasing for our own gratifications?

Making this decision to base your way of living on what is pleasing to God will free you from the bondage of tradition—a way of life passed down through generations and followed with blind participation, with little consideration of when, why, or where these traditional beliefs came from.

Growing up in the belief of traditions, I had some family members who practiced as Jehovah's Witnesses. As a young person, I attempted to learn about different religious beliefs in my society but was always turned off by their ways, which didn't seem normal to me or didn't match the beliefs I was taught to believe in. My beliefs had more sparkle and made me feel like my ideas were independent of someone else expectations. As an adult, I wanted to study world religion (I thought this would be very interesting) until I realized that the things I thought were just Zen or even stemmed from an exercise for the body, mind, and soul also considered a religion. No way had I thought about how certain beliefs could be considered religion.

During the times that Jesus walked the earth, did he ever mention any of these holidays that we celebrate today? Did he tell us to always honor our Father by doing so? Or did these holidays emerge over time, made up by man so that society could celebrate because they wanted

to have celebrations in God's name, thinking this would honor him? Not that he had asked of us to do so, but because we thought this would honor him in a way that he would be pleased. When God has asked you to do something, this is what he wants you to do. He doesn't want you to make up holidays based on pagan beliefs. Just wants you to follow the Word of God, and you will know what direction to go in your daily life. When God points the direction in which you should go, go with his blessing; know that is what he wants of you. When we desire things that we think will please God, but God has not mentioned these things in the Bible, then we take the chance of transgressions of idol worshipping. "Set your affection on things above, not on things on the earth" (Colossians 3:2). Follow God and let him lead you to eternal salvation.

Because I didn't know the real meaning of the origin of some traditions, I fell into the trap of believing what I saw on the exterior as being the truth. To understand and know the truth of my traditional beliefs helped to get me the clarification of what was Christian and what was pagan. I only ask that you do your own research and see how each tradition has been based on pagan beginnings. From there, you can determine if you should continue your traditional beliefs or place yourself in God's hand, with his Word in tow to guide you through your way of life.

I myself once thought of those who did not celebrate traditional ways as practicing a very sad way to live. But as I grew in faith, my eyes opened, my thinking changed, and my way of life became more peaceful. If you do not get a Christmas present or birthday gift or any pagan greeting from me, know that my love for you is every day, not just on special occasions. So when I say a kind word, sacrifice my need for yours, or lend an ear to the way you are feeling that day, know that God gave each and every one of this day and every day, not just special days, to be loving and kind to one another as his Word tells us to do. When we do this, we are honoring him by our words and deeds. There are a lot of things in this world that can fill a moment of peace and happiness in our lives. But only following God's Word can have and give the peace and happiness you seek that is everlasting in this world. Material things tarnish, but to honor God is to do as he asks, not to follow paganism.

Following a way of life condoned not by God but by the wishes of man—a way that satisfies man's desires and not the way God wants his children to live—will only bring dissatisfaction in the long run. For such a way of living is only self-satisfying and not uplifting God or his plans for humankind. Our way of life has led us down a path that can be reversed if the desire to honor God, not man, is your life's intentions. You can live as God has asked of you and not continue to follow the status quo.

I have noticed that people will start to label you with a particular religion or sect when you decide to follow the teachings of the Bible. When I read my Bible, I could not find where we were told to practice a celebration for Christmas, Easter, Halloween, and Valentine's Day. Take the time to question the traditions you celebrate and how they originated. We should not transgress against the commandment of God for our traditions. Our way of life can lead us into oblivion of highs and lows and not along a straight path to God's will.

Each day, upon awakening from our sleep, we should honor and obey our Father in heaven and be thankful for another day that he has given us. We should not be tempted to fall prey to the paganism still practiced in our world today. The different symbols that depict the different holidays we celebrate have pagan beginnings and have nothing to do with God or anything in heaven, only Satan and his followers.

The world we live in has evolved into a mass of mixed directions. Many have adopted mixed perceptions of the true meaning of God's Word, simply because people have dissected his Word to mean what best suits their own beliefs. They've followed their own reasoning when it comes to life's journey, rather than God's plans for his children—resulting in a world of mixed messages from different religions and sects. When life is broken down to a simplistic way of thinking, things are not so complicated. All can be seen through the eyes of the just in heart and soul—the believer in God's Word. Traditions can drive a person in a direction in which they know not where they go. They will end up in a place where there is no return to an honest perspective and to a life lived as a child of God. When people take the path that God has planned for them and not a path they think is best, their mind's eye will

open to a window of quiet perception. They will see what they need to do and should do to fulfill God's true plan for them.

Satan and society will interfere with your reasoning in this world, to the point where the lines drawn seemed blurred and distorted, and you may feel that life is a coin toss. Traditions can make us feel cemented in what we believe and that change is not an option. We always have a choice. This is our God-given right, which God has blessed us with. Choosing the direction you take is not mandatory but, rather, necessary in order to make the right choices in life.

When following traditions, we do not always question: Is this what God wants from us, what he expects of his children? The Bible always has the answers to life's questions. When we follow God's Word, only then can we know we're going in the right direction. When we follow traditions, we follow other people's idea of what we should be celebrating, not what God has asked us to do. Traditions are strong in nature; they come from our beliefs, based on what we've been taught to do and what has been passed down through generations, for the most part never questioned.

What is acceptable to God is where your acceptance of tradition should lie. You may notice that none of Jesus disciples celebrated Christmas, Easter, or any of the holidays we celebrate now. That's because, only after centuries had passed did the Christians want to have celebrations like the pagans. So they copied from them and their celebrations, with a twist, working in their own Christian beliefs. This did not come from God's Word. We should not transgress against God's Word because of our traditions. Man has commanded these traditional celebrations, not God. All Christians and any religious sects should question their traditions, asking, Are these things that God has asked us to do in our daily lives? Christians should not be imitating pagans. We should not follow pagan beliefs with our interpretation of what God has not even asked of us.

Should we all conform to the world in our traditions or with the truth? We should question our traditions in order to know why we celebrate the holidays we celebrate and not just follow blindly what other do simply because this is what has always been done through the centuries. When you question a tradition or study the beginnings of any

particular tradition, you will discover that it's not sanctioned by God but, rather, has pagan beginnings—taken over by Christians in order to satisfy their own desires to have celebrations they felt were acceptable to God. We celebrate many holidays during the year that do not coincide with what God has asked of us, like Easter and Halloween. Shouldn't we know why we celebrate these traditions and not just follow popular beliefs?

It's amazing to me how we can follow a tradition whose origins we don't even know. This reminds me of the blind leading the blind, and we all fall into the same ditch. Following the masses just to keep from appearing different from others is not always the best way to go. We must value the life God has given us by living the way he expects of us and not just pleasing the populace. Most of the tradition we know why we celebrate due to history over the past several hundred years or more. But the ones passed down from ancient times have been around for such a long time that have evolve into Christian beliefs that we just follow them without question—because they sound good and because we have been taught that these are days we should celebrate in God's name. Or should we?

Chapter 2

Transgressions of Idolatrous Feast

When we as a people transgress against God, we come short of the laws set by God and what he has asked of his children. And when we idolize certain traditions, we feast with Satan. We can only break the chain of idolatrous behavior by following God's plans for us, not our own itinerary, in the belief that we should follow the path always taken by society. An idol is nothing in the world, and each meal we partake of is a blessing from God and should be acknowledged as such. "Whether therefore ye eat, or drink, or whatsoever ye do, do all to the glory of God" (1 Corinthians 10:31). We should be followers of God and not of society's expectations. A sin is a transgression against God. It is said that the path by which the Lord leads us is mercy and truth so we may keep his way in our heart, mind, and deeds daily. "Have mercy upon me, O God, according to thy lovingkindness: according unto the multitude of thy tender mercies blot out my transgressions. Wash me thoroughly from mine iniquity, and cleanse me from my sin. For I acknowledge my transgressions: and my sin is ever before me. Against thee, thee only, have I sinned, and done this evil in thy sight: that thou mightiest be justified when thou speakest, and be clear when thou judgest. Behold, I was shapen in iniquity; and in sin did my mother conceive me" (Psalm 51:1–5).

Life's journeys take each one of us on our destiny's path, which we must travel down to experience our own place in this world. We must

tread through life's experiences with a pinch of precaution and a dash of faith, never losing hope in our endeavors. When we transgress against God's laws, we shorten our path and take dangerous steps toward an unforgiving world of chaos and regret. How long we live on this earth is determined not by us, but by God's plans for us on earth and how we use that plan. The old saying that only the good die young and that the evil persist is only the belief of those who have little faith in what God's plans for each of us shall be. We should not feast on our transgressions, for this is to idolize a way of life. There is a reason for every purpose in life, even when we cannot see the whole story at the time it has unfolded before our eyes. If you travel down your own path without God's guidance, your life will unfold before your eyes as a life of transgressions, regrets, and a whole host of things you wish you could change but cannot. This leads you down the only path you have. And that is to pray to God to give you the understanding and the tools to deal with the truths along your journey's path in order to be the person he expects from the life he gave you.

Always pray to God, asking him what he would have you do. There must be balance in your life when it comes to what you celebrate. You must celebrate days that do not have pagan beginnings or anti-Christian origins, as done in the Bible. Celebrated days should not promote false doctrines or immorality. Idolatry is seated in pagan beliefs and will bring a person face-to-face with transgressions of idolatrous feast at Satan's table. A person should not delight in something God despises. "All we like sheep have gone astray; we have turned everyone to his own way; and the Lord hath laid on him the iniquity of us all" (Isaiah 53:6).

Jesus has paid for our transgressions. So we must steer clear of sin as best we can and not fall into a trap set so easily by humankind—of which Satan is a part—that helps blind us to the truths of what God expects of his children. When we gather together, it should be in remembrance of what God has taught us to do in order to truly follow his teaching—to help one another in a way that is uplifting and merciful to others who we live beside. When we pray for understanding of God's Word, only then can we be led to knowledge of what will not guide us to idolatrous behavior.

When we as a people follow in the steps of idolatrous behavior, which in return is a transgression against God and what he has asked of his children, this brings us to the deep end of a raging river, where we can be swept away, never to realize that we have been blinded by social norms disguised as what God want from his children. Nowhere in the Bible can you find where God has asked his children to celebrate any of the holidays we celebrate today. These holidays we celebrate in modern society derive from pagan beliefs that have been transformed into Christian beliefs with a twist from pagan folklore. Let us not transgress with idolatrous behavior just to follow customs. Read your Bible and see the truth of what God has asked of his children, not what society's norms have asked, for Satan has misled us in so many ways that seem harmless enough. But we must keep our eye on the prize and follow in the direction of the path that God has laid out for his children in the Bible, for this is the only true path to salvation. Each person should do their own research of the holidays we celebrate to see what idolatrous behavior against God is and what is pleasing to our Father in heaven, who can grant eternal love for all those who believe in him.

A person's belief should be in God, not in imitating pagans. Think about each holiday we celebrate and how it came about and then read your Bible and see how it transgresses against God's plans for us."Take heed to thyself that thou be not snared by following them, after that they be destroyed from before thee; and that thou inquire not after their gods, saying, How did these nations serve their gods? Even so will I likewise. Thou shalt not do so unto the Lord thy God: for every abomination to the Lord, which he hateth, have they done unto their gods; for even their sons and their daughters they have burnt in the fire of their gods. What things soever I command you, observe to do it: thou shalt not add thereto, nor diminish from it" (Deuteronomy 12:30-32). We all should be aware of who we listen to and how we conduct ourselves. Always be aware of what God expects of his children by following his Word, not society's traditions, led oftentimes by Satan and his demons. When you do what is truth, then it is true. We should all look inward and fine within ourselves what God tells us to do from reading his Word. You can find the truth where the truth is written.

God, not man, defines how he should be worshipped. When we take it upon ourselves to just follow something or someone without knowing the whole truth of the matter, we can easily become blinded by societal norms and follow a way that is not ordained by God. It is so easy to just get into the mix of life and be like others, for after all, we do want to fit in. But think about it for a moment. Don't you want to know why you're doing what you're doing? Or are you a trendy person who just follows someone else's ideas of what is in now? These holidays we celebrate have not always been. They have been brought in, taken out, and brought back again according to the whims of society—none of which has to do with the Word of God or what he has asked of us. Each person needs to come to their own conclusion because we all have our own perspectives. But when you understand the history from which these holidays derive and what the Bible says and does not say, then and only then can you see your transgression of idolatrous feast against God. Be a follower of God's Word, not the whims of man, for we should not follow the blind. Only with open eyes can you see the way that the Lord wants you to travel.

When paganism is dressed in Christianity's clothes it makes the practice almost indistinguishable between Christianity and paganism. The idolatrous feast of man seems normal to society because the church has sanctified the belief in these holidays. Doing your research will show you not only when and how these holidays came about but also how these holidays have corrupted the true understanding of what God really expects of us and not what man thinks God expects of us. When we live by the world's standards of what we think we should do to honor God, then we lose our perspective of what is the truth told to us in the Bible, where God's teachings are available to all who believe in him. Satan will always make the here and now more persuasive—with big and bright, shiny things that entice man. Remember the old saying that all that glitters is not gold; this will always hold true. Holidays are pretty, nice, and shiny things that make us feel good about ourselves as humans who live among humans. We are here to honor God, not to bask in shining, pretty things, for we must do what God has asked us to do. When you follow God's Word, life takes on a simple and direct meaning that everyone can follow. His Word is not just for the rich, well-educated,

and beautiful people to follow, leaving the poor and unfortunate in a place of uncertainty with each passing holiday.

Whosoever transgresses against God's commandments will not prosper in life but, rather, will live in the constant chaos of the things that surround them in their way of living. When God asks us to do something, it is for the benefit of humankind. If he does not specify that we do certain things, then he himself knows that they have no significance when it comes to our well-being. Idolatry only serves the purpose of the person who participates in the transgression. It doesn't serve God. In the Bible, he only asks us to do what he wants us to do. For centuries, man has followed pagan beliefs that have been passed down through the ages by the church, family members and friends alike. And most people do not even know how it all originated. They just go along with the program, not questioning whether this is what God has asked of them or whether this is just a pagan religion passed down by those who thought this would please God.

When we pray to God, we should ask for guidance in our daily life and read his Word, for the truth comes only from him and not from our earthly traditions. When you do the things God has asked of you and not those demanded by society, life takes on a simpler meaning, calmness fills your soul, and you'll be given a much easier path to follow.

When you read about the ancient gods and goddesses, the beliefs of the people during those times, and how they celebrated their holidays and festivals, you will see the pagan relationship between what they believed and what God has asked of us that is written in the Bible. Always reference your Bible for the truth of what you need to believe in when living your life. If you are an adult and have lived many years, then you can see what God has taught his children is to serve them best in keeping them from losing their souls to the deceitful and lying Satan. Living your life in honor of God is different than living your life to please only yourself, for your eternal life should always be what keeps you strong and on the right track in life. Anything else is a fleeting and short-lived promise from Satan that you know best, not God.

We are not heathens and should not be celebrating festivals of old traditions and pagan ways of life. The churches have led us down the wrong path by adding paganism to Christian beliefs. They have studied

these ancient beliefs and know where they come from, yet they still teach it to their congregations like it came straight out of the Bible.

The Bible does not instruct Christians to celebrate such holidays as Christmas, Easter, Thanksgiving, Valentine's Day, or any of the days we celebrate during the year. Nor does the Bible speak against celebrating holidays. The Bible mentions celebrations that the Israelites observed, such as Passover, Pentecost, Purim, and New Moon. But the difference between these holidays and the holidays celebrated today is that some of our modern Christian holidays have pagan or even anti-Christian origins. Now the works of the flesh are manifest, which are these; Adultery, fornication, uncleanness, lascivious, Idolatry, witchcraft, hatred, variance, emulation, wrath, strife, sedition, heresies, Envying, murders, drunkenness, reveling, and such like: of which I tell you before, as I have also told you in time past, that they which do such things shall not inherit the kingdom of God. But the fruit of the spirit is love, joy, peace, longsuffering, gentleness, goodness, faith, Meekness, temperance: against such there is no law"(Galatians 5:19–23).

This leaves Christians with a difficult decision in regard to holidays. Should a practice that started as a pagan religious ritual be continued? Pray to God and ask him what he would have you do. "If any of you lack wisdom, let him ask of God, that giveth to all men liberally, and up-braideth not; and it shall be given him" (James 1:5). God speaks to us through his word, which is written in the Bible. We can find our answers here. If a person took time to study how each holiday came about, they would be surprised at its pagan origins. The Roman Emperor Constantine feigned becoming a Christian and was not baptized until he was on his deathbed. He only wanted to consolidate his rule by incorporating the pagan holidays and festivals into the church rituals to attract the pagans but by giving the holidays and festivals new Christian names and identities, thus appeasing the Christians. This was his deception, which caused Christian churches to follow and embrace his clever way of disguising paganism as Christianity.

This leaves Christians with a hard decision to make, considering most have spent their whole lives celebrating holidays and festivals that they did not know had a pagan beginning. People will judge you for questioning such traditional beliefs that have gone on for hundreds of

years, though they cannot tell you how they were started. And it's not clear if knowing their roots of paganism would even change their minds about whether or not to celebrate these traditions. People know the Bible is to help guide them in the right direction, but do they want to go in the direction that the Bible is leading them—not when it's leading in a direction other than the way they wish to see themselves go. When you pick the direction you want to go in, and not the direction that God would like you to follow then you are taking the chance of not being guided by the love that surrounds you that God gives freely and unconditionally.

We all have the choice to believe or not to believe in God's Word. Think of who has your best interest in mine—God or Satan. Who gains the most if you lose your soul for an eternity of pain and suffering? Nothing that God has ever asked of us has led us in the direction of pain or suffering.

When we understand the meaning of life and our purpose here on earth, then we will understand what God expects of us his children. Our lives here are to serve God and follow his commands. If everyone did this, life could be simpler and more glorious for all his children. When we take it upon ourselves to follow only the things we often find false hope in, then we compromise the world we live in just to justify our means. Pagan beliefs that have transformed into holiday delights have led the Christian faith into the oblivion of blindness and despair—for both young and old and for the rich and poor. God's love for us is not trickery and will not give false hope to those who believe in him. His truth is neither myth nor confusion to our souls. All that he asks us is simple obedience to his Word. When you read the history of paganism and how it has been incorporated into our society, only then will you see with clear vision what God has asked of you. We all want to be a part of the world we live in but not at the expense of our souls. Life is to be lived to the fullest with God's spoken Word in our lives to lead us down the right paths in life. No one has ever faltered following the Word of God.

The blind will follow the blind. Open your eyes to what and why you do what you do. Follow what God, not humankind, teaches you to do. "Rejoice evermore. Pray without ceasing. In everything give thanks: for this is the will of God in Christ Jesus concerning you" (1 Thessalonians

5:16–18). "That ye may be blameless and harmless, the sons of God without rebuke, in the midst of a crooked and perverse nation, among whom ye shine as lights in the world" (Philippians 2:15).When we attempt to redefine a pagan holiday with a Christian meaning by doing what people do on these holidays—gift giving, decorating Christmas trees, hunting for eggs and awaiting the Easter Bunny—we succumb to paganism. Life as we know it should always keep God, not symbols of idolatrous feast, at the center of our belief system.

There are several celebrations in the Bible that God did ask the Israelites to observe. The difference between these holidays and the holidays celebrated today is that some of our modern Christian holidays have anti-Christian origins. God is very clear in his directives against the celebrations of pagan holidays. Please do not honor any pagan Gods.

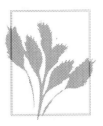

Chapter 3

Truth, Not Lies

When you study the Bible, you will soon come to know that nowhere does God ask us to celebrate the pagan holidays we celebrate today. And reading the history of pagan celebrations, festivals, and the like will soon lead you to the truth—or the lies—when it comes to our so-called Christian holidays that only mimic pagan beliefs. We have celebrated these holidays without question and have followed the pack for so long that some of us cannot differentiate between paganism and what God has asked us to honor. Truth and lies cannot be mixed, for they are polar opposites. And like the Bible says, you cannot mix the profane with the holy and make it all right with God.

If you want to celebrate the birth of Jesus or his resurrection after dying for our sins, read the Bible and do as God has asked of you. Do not follow traditions without questioning their beginnings. Do you want to even know the truth? Or are lies prettier to you? Read your Bible and see if you can find where God has asked you to honor him by taking pagan holidays and turning them into Christian celebration. Always look for the truth, which does not always follow the pack.

When you follow in the footsteps of others, do you blindly follow traditions, not caring that they originated from pagan beliefs? Do you like having a special day set aside for holidays, instead of following God's Word every day? Do you believe God's Word to his children is for special occasions or for everyday use in your daily living? Always

remember that the Bible says you cannot mix the profane with the holy and expect to please God; he is not pleased. When we do so, we are only trying to please ourselves. Do what God has asked of you and then and only then will you please him.

I do not condemn people who celebrate Christmas or any holiday. But if you want to, you can seek what our Savior's will is to know how he feels about it. Remember, it is about him, not you. Just because we celebrate a tradition to honor him doesn't mean he sees things that way. To celebrate pagan traditions is to honor God in vain, for it was not commanded by him but, rather, an invention of man). If God wanted us to celebrate Jesus birth, I believe he would have given us his birth date. What is popular is not always right. We cannot follow the masses if the masses are wrong. Following the Word of God will always lead you in the right direction.

In doing my research on pagan holiday traditions, I talked with different people about their beliefs and why they celebrated these holidays. Some did not know they were considered pagan and they took the road of "didn't know, don't care. I like celebrating the holidays because of the camaraderie of being with family and friends." Others participated because this was what their church had taught them to believe and they hadn't read the Bible or researched how these holidays came about. Some knew that many holidays that are celebrated are considered pagan but chose to celebrate in their own way with family and friends.

There are about twenty-five pagan holidays that are celebrated in the world. So I guess we can consider ourselves a pagan society. I believe that we should forget the pagan traditions and honor God in our everyday living—by doing what he has asked of us, his children. Honor God with your belief and faithfulness in him on a daily basis, not by following a tradition based on paganism. Do not follow others blindly with no knowledge of when, why, or what you're doing—lest you fall into the pagan traditions of today's societies.

"Let's hear the conclusion of the whole matter: Fear God, and keep his commandments: for this is the whole duty of man. For God shall bring every work into judgment, with every secret thing, whether it be good, or whether it be evil" (Ecclesiastes 12:13–14).

Pagan influences on Christianity are the reason many Christians were converted from paganism. Now we call ourselves Christians, but we still practice pagan beliefs that are shrouded in Christian traditions. These celebrations look pretty, but do they reflect the truths of what we're supposed to do in order to honor and follow our Father's commandments for us? If we can follow traditions, why can't we honor him and follow his Word?

When I spoke with people to get their opinions on why they celebrate the different holidays, it all came down to family and friends, not God's plans for them. Honor God with your everyday activities throughout the year by following his Word. The Bible shows us the way. If you do not study the Bible, you are following the ways that someone else perceives God. Get a companion study Bible to help you understand God's Word. Do not be the one who knows but doesn't care or the one who cares but would rather follow tradition.

Your plea to God will be in vain as a sinner on the great day when you follow your guides and not the rules of God. When you do as others do, then you must go where others go, even into the lake of fire. Understand the world we live in and how the influence of others can take you away from his Word. God's Word must influence your daily life with joy, knowing you are his child, And you should follow his rules, not society's traditions.

Having glimpsed some light in my own life after having lived many years, I would like to see others do the same, Remember, "The road to hell is paved with good intentions." Live and learn, I have always said. And don't let every day lived be wasted and regretted until you are at the point of no return. Peace of mind, body, and soul are what gives a person sanity in life. Whatever question you have, whatever problem you are experiencing, whatever your situation is, the answer can be found in the Bible. All answers to your life are found there, for the Word of God is to guide us in the right direction. Too bad we are not always pointed in the right direction when we are either young or older in life.

Many people keep the holidays and traditions because it is easy, natural, and comfortable for them to be in step with others. They assume what they believe is right, and they never take time to prove it to themselves.

Here is what Christ said about popular customs and traditions of the world: "Howbeit in vain do they worship me, teaching for doctrines the commandments of men. And "he said unto them, Full well ye reject the commandment of God, that ye may keep your own tradition" (Mark 7:7, 9). Saturnalia, Janus, and Eostre were celebrated in Rome long before Christ was born. Nowhere in the scriptures is there an endorsement of celebrating Christ's birth.

There are about twenty-five holidays and traditions that have pagan origins. Study the things you believe in and their origins and study God's Word for the truth and what he wants us to pay attention to in our lives. Read about pagan influences on Christianity and how that influence has swayed our way of living. Do not be led down a path of falsehood of Christian traditions that are not sanctioned by God's Word and the way he wants us to live our lives.

Remember that you cannot serve two masters. Each holiday derives from a pagan belief that has been perpetrated by the Christians and other religions, not God. I will list for you each holiday or tradition that was born out of pagan-rooted traditions; you do the research. These include Christmas, Easter, the Feast of Annunciation, Halloween, New Year's Day, Valentine's Day, Mardi Gras, Thanksgiving, Purim, Hanukkah, birthdays, May Day, Nowruz, Chaharshante Suri, Ash Wedesday, Lent, Chinese New Year, Mother's Day, Earth Day, Ramadan, Diwali, Feast of the Tabernacle, Rosh Hashanah, St. Patrick's Day, and Nativity of John the Baptist.

Please do not forget God and believe in falsehoods. God has taught us the things he wants us to honor. And none of these things originated from pagan traditions or beliefs. When you look for the truth, God will show it to you. When you seek falsehood, Satan will blind you with the worldly way of living so that you will feel comfortable following in the footsteps of others. Read your Bible, do your research, and follow the things God did ask you to do.

God is the only one who can save you. Follow his Word, so that you may live in the truth of his plans for you. You will not learn what God wants from you unless you open your mind and heart to his Word. The people who don't follow his teaching believe in living the worldly way of existence so they can fit in with the world around them. No matter what

your lot is in life, following God's Word in your life will give you more love, peace, hope, and faith in your future. Truth, not lies will surely clear your life of clutter to give you space for what really matters in life, doing unto others as you would have them do unto you.

Try to understand that most Americans have reinvented holidays and traditions to fill the cultural needs of a growing nation that keeps up with what is most popular in the world. Each pagan belief has been built upon over the centuries to create a sense of tradition that makes observing these commercialized days something that God approves of. Each popular tradition has been embedded in our psyche. When you do your research, see if your beliefs are following what God has asked of you or what the world is telling you to do.

When you read your Bible, see if you can find anywhere that God has commanded you to keep the celebrations we honor today. Some of these days we honor were never celebrated during Jesus times by him or his disciples. When you read the history of how each holiday or tradition came about, ask yourself if you want to honor a day that God did not sanction—a day that was derived from paganism and transformed into Christian or other religious dogma. To find the truth, we must seek the truth, not follow or be led by the blind, who do not lead us by the way of God's Word.

A lot of us have followed in the way of customs given to us by our upbringing, not questioning the reasoning or source of our beliefs. When you make changes in your life to please God, not society, of course it feels strange and you feel like an outcast. But this is where you gain your strength in being a child of God, not Satan. Why would you celebrate a day that you knew was considered an abomination by God? Are you willing to lose your soul so you can fit in with others? Should a practice that was started as a pagan religious ritual be continued? Pray to God and ask him what you should do. If you do the things that he asked of you, then you will be safe from the list of things he asked you not to do. These things you will read when you open your Bible; all instructions are there for any situation we may encounter.

When Christianity was legalized and paganism was prohibited, pagan religions were increasingly persecuted. Lay Christians took advantage of these new anti-pagan laws by destroying and plundering

the temples. In the year 416, under Theodosius II, a law was passed to ban pagans from public employment.

Paganism is still practiced today in a mannerism that is cloaked. The disguise is so good that people really think they are pleasing God while acting in a way that is worldly and not asked of us by God in the Bible. They are the blind being led by the blind, and that is why I suggest you read God's Word to understand the truth of what he has asked of his children. Those who are blind or set in their ways and beliefs will not care to read their Bibles to seek the truth. When you study God's Word, you will open up to the way of the Lord's teaching and see what he has asked of you and not what the world expects of you. When you feel ashamed to discuss or believe in God in your life as his child, he will deny you his grace and mercy. I never ask a person to take my word. Just study your bible and ask God to give you understanding of his Word so that you may live your life with his love and mercy. No life is without strife, but the things you do that are sanctioned by God will show your obedience to him, not Satan.

When we look for the truth of any matter, we look at the historical facts of where it originated from. When you study the Bible, you can see the facts of Jesus teachings and what God has asked us to do and not do in his name. This you can take to mean fact or worldly traditions of humankind. When seeking out God's will to honor him, make sure he sees it that way. Remember, it is about him, not you. "Blessed are they that do his commandments that they may have right to the tree of life, and may enter in through the gates into the city" (Revelation 22:14). When you study paganism and how it is connected to our traditions of today, you will discover the lies that have been perpetrated throughout the centuries by people who believe they are honoring God but aren't looking for the truth in the traditions and why we practice them. Most people want the truth. Some care more about the practice and will believe whatever they are told. Remember, all our days are to be dedicated to God through holy living and godly service, not always by celebrations. Honor God just by doing what he has asked of you to do. Most traditions have a commercial side. Do you think this is what God has asked us to do? Or are these pagan traditions entwined in our beliefs? Think about it.

The memorial of Christ's death and resurrection is through baptism, not holidays and old traditions brought on by humankind. All these rituals that he did not ask you to do to honor him are borrowed from the pagans. Christianity has been filled through the years with fanciful things of delight to intrigue humankind with magical beliefs that have no place in the worship and honor of God. No true Christian could participate in pagan traditions. The Christian churches have embraced paganism and blurred the deceptions that have allowed in paganism over the centuries:

My little children, these things write I unto you, that ye sin not. And if any man sin, we have an advocate with the Father, Jesus Christ the righteous: And he is the propitiation for our sins: and not for ours only, but also for the sins of the whole world. And hereby we do know that we know him, if we keep his commandments. He that saith, I know him, and keepeth not his commandments, is a liar, and the truth is not in him. But whoso keepeth his word, in him verily is the love of God perfected: hereby know we are in him. He that saith he abideth in him ought himself also so to walk, even as he walked. (1 John 2:1–6)

And as we all should know or have read or heard of, people do not often make decisions based on the truth. Life is not that complex. We just make it that way. God has laid out a map for us to follow so that we can minimize the wrong turns we make in life. We just have to read the Bible to follow the true path that he wants us to take. The truth will set you free from spending energy on nonessentials in life and will give you the power of living a full and healthy life that God wants you to have while fulfilling your dreams in life and succeeding as a child of his. Truth or lies—make your choice of which journey you will take. Our belief in God's Word means believing in what he tells us to do, not what we prefer to do when it comes to following society's traditions and beliefs and what *we* see as acceptable. If you believe in God, then you will believe in the teachings of Jesus Christ. His teachings show us how we should honor God, not ourselves. Again, study your bible; all you need to know is there. The scriptures will lead the ones who are not blind to a place of serenity on earth, not a sinkhole of false doctrines and lies.

The truth is in the Word of God, not society's fairy-tale dreams of a white Christmas, a spooky Halloween, an Easter Bunny with colorful

eggs, or any colorful holiday spun out of someone's imagination. Life is simple. People make it hard by following the pagan beliefs of ancient stories and truly made-up tales of long ago. An understanding of what God wants from you comes strictly out of the Bible and not from pagan tales. The Bible leads us down the right path, and we do not need to add or take away from it.

Always ask God to guide you in your endeavors, for this is the only sure way of going in the right direction in a time of turmoil or a quiet introspection of what is best for you. Every day is a new day, a new beginning in your life. And you deserve to know what is right, what is truth, and to not be fed a lie that will lead you off a cliff to your demise. When you ask God for help, he will lead you in a way that will give you peace in your everyday living. He will open your eyes for you to see what is true, and what is lie. When you follow his Word, you have no fears or doubts that every day is a good day, because you are following his Word and not society's idea of the way you should live.

Chapter 4

Things God Has Asked of Us

We all must follow God's law, for we all will perish without it. We must do the things God has asked of us. This will give us The harmony we need for our life on earth. When we study the Bible, it gives us nourishment to live a life of surplus. Without God our substance is weak. Sure, money makes us feel strong, but false God's will do that to the human psyche. When you let go of humankind's history of pagan beliefs and follow the things God has asked of you, then false teachings will fall away like a rain shower leading to fresh air to breathe. We do not have to guess how God wants us to live our lives; he has laid it out in his Word—no mysteries there. One sure direction he has given us is, "Do unto others as you would have them do unto you." No one is innocent from sin, for we are all born into it. But we can rebuke it by following what God has asked of us. Just study your Bible, and trust that God is leading you into a more fruitful life and an eternal blessing that will bring you into his house of light with no more darkness in your days. His light will guide you through the storms that plague us all from time to time.

There are rules that I follow in my daily life that I find uplifting and that make following the things God has asked of me easier. Rule one do unto others as I would have them do unto me. Rule two, stay away from anything that is illegal, immoral, or unethical. Simple enough for a child of God, don't you think? Like I have always said, life is easy. People make it hard for themselves and others. When we take life one day at a time,

it's easier to digest than to swallow what may or not be or what could or could not be. Do not dwell on a situation until you make yourself sick. Sort it out, and then tackle it with a step-by-step perspective, knowing only through prayer and understanding what you should do. Sometimes God does not answer our prayers. He lets us figure it out ourselves as a learning experience. A person learns the good side of human nature that way. He helps us to bring love, compassion, empathy, humility, thankfulness, forgiveness, giving, and so much more into our lives. We can develop a renewed spirit in our actions and thoughts and have a mindset based on Christ teachings

And saying, Sir, why do ye these things? We also are men of like passions with you, and preach unto you that ye should turn from these vanities unto the living God, which made heaven, and earth, and the sea, and all things that are therein: Who in times past suffered all nations to walk in their own ways (Vanities in the OT denotes false Gods). God will show us how to be in the world but not of the world. "And be not conformed to this world: but be ye transformed by the renewing of your mind, that ye may prove what is that good, and acceptable, and perfect, will of God" (Romans 12:2).If you believe in God, then you believe in his written Word and not just the things that you agree with and follow in your daily life.

I know some things seem quite biased against women. The Bible was written long ago, and we live in a different time now. But I believe the rule is still to do unto others as you would have them do unto you—a rule that transcends time. And time will transcend God's Word, which will give power to the innocent and the powerless of society and release the stronghold that people have on another. I believe people will be judged by God for their deeds on earth, what they were placed in or put themselves in, and how they overcame their strife or mistakes to live the life of a child of God, no longer living by the world's standards but in a world of God's standards for his children.

The Bible tells us, "Do not be anxious about anything, but in every situation, by prayer and petition, with thanksgiving present your request to God."(Philippians 4:6-7). We are not saved by one deed but by our faith and the grace of God. Always seek guidance from God, and you will be led in the right directions, for only Satan leads people in the

wrong direction. As a child of God, having a conscious, you will know when something feels right or wrong. Do the right thing. God shows us the truth when we follow his Word. His Word might not be what you want to hear for your situation in this day and age, but the truth will set you free. Ask for forgiveness for your sins, and you will be forgiven. Then move on and follow his Word, and life will become less complicated. Just keep things simple in your life, and things will work out much better, because a lot of burdens we incur in life we bring on ourselves by following Satan, not God.

Read your bible and think about the things that have happened in your life; did these things happen because you made a wrong choice? Or did someone evil make the choice for you when you were not capable of making your own choices in life? Either way, now as an adult, you can flip the script and follow God's Word. The more you do so, the better things will get. Some people will never change, and some things in life will never change in life. But the way you handle things that come your way will be dealt with in a way that will give you peace of mind, knowing you did the right thing.

God places and keeps us on the right path. "All scripture is given by inspiration of God, and is profitable for doctrine, for reproof, for correction in righteousness: That the man of God may be perfect, thoroughly furnished unto all good works" (2 Timothy 3:16–17). If you love God, keep his commandments and follow his Word. God will show you the truth. All you need to do is read the Bible, use your study Bible as a companion to help you understand his words clearly, and ask questions of Bible-based teachers in your community.

If you don't want to do as God has asked of you and prefer to follow what the world is doing that is not in conjunction with God's Word then know that the wages of sin is death, but the gift of God is eternal life in Christ Jesus our lord. Jesus taught us many things when he walked upon earth—things that would help us in our lives to keep the faith and stay strong in our belief in his words—which were given to the people on earth forever and forever. Do not lose faith in our heavenly Father, and you will be forever guided down the right path. But when you let Satan enter your life, peace, love, and understanding of God's Word will elude you, and you will be blinded to what God expects from you as his child.

Some people find it hard to do the right things because they are very set in their worldly ways, which they have abided by and feel quite comfortable with. People feel comfortable with the things they are accustomed to. When you vary from the usual norm, you feel out of place and out of step with what is expected in this day and age. Since people want to fit in, being different from others can make you feel like the odd man out. Read your Bible and then ask yourself what God has asked of you verses what society has asked of you. Then contemplate who has your best interest at heart. "And that servant, which knew his Lord's will, and prepared not himself, neither did according to his will, shall be beaten with many stripes. But he that knew not, and did commit things worthy of stripes, shall be beaten with few stripes. For unto whomsoever much is given, of him shall be much required: and to whom men have committed much, of him they will ask more" (Luke 12:47–48).Have peace of mind when doing what God has asked of you. Or do as you please and throw caution to the wind, saying, "But I am a good person." (As you might not know, God does not favor lukewarm personalities.)

When you do as God has asked of you, things in your life fall into perspective. Things in your life, such as how you handle situations and accept and deal with everyday problems, become clearer. "Preserve me, O God for in thee do I put my trust" (Palms 16:1).We get our strength from the Lord in our daily living. He gets us up every morning and gives us peace and tolerance to help us do kind deeds and gestures for others, and then when we lay down in our bed at night, he gives us restful sleep. This is done every day that you try and live your life by his Word. No day is perfect. No day is guaranteed, but hope helps his Word prevail in your life, and life is a day-by-day experience. When you live as God has asked of you, things will not become easier in your life, only your perception changes and things will appear differently when you look at it in a different light. Life will show you the way by the will of God to guide you. Stay strong in your belief in God's words, for they will comfort you when you hear them, read them, or say them. Remember, God is always with you, and nothing you do or experience is without his knowledge.

Ask for his help, for you will always need it. No one can live without his help in their daily life. God knows where you come from, and he

knows where you're going; let him guide you, rather than being guided by the worldly way of living. When we do what God has asked of us, we cannot go wrong. Mistakes are made from time to time, but when we pick ourselves up and try again, it does not go unnoticed by God. No one is perfect, of course, but that's no reason to not try and obey his Word. When you live only according to your way of thinking, showing your unwillingness to conform to his teachings, he will not be able to redeem you from Satan's grip on your life.

Yes, Satan will always try, but having faith in God will keep you in a place where Satan cannot have you, for you are a child of God. If you let Satan get a grip on your life, this will weaken you and make you more vulnerable to the evil in this world and more easily persuaded to do Satan's bidding. I know that we all lose our grip on life from time to time, especially when times get tough, But like I said, know that God is always with you. Gain strength in your daily life by reading his Word, living his Word, and obeying his Word.

I believe you can obey God's Word and respect others in their beliefs also. We are to treat one another with love and respect, with kindness and empathy. Each person has their own perception and understanding of life and how it should be lived. Let God do the judging—hence, judge not. When you judge others as if you are spotless from sin, then you will be judged. Judging also places you in contempt of God teachings that we must do unto others as we would have them do unto us. Only God's Word can make things clear to those who seek the answers to their lifelong journey. When we do as God has asked us, life pathways becomes a clearer road to travel down. Every day lived usually teaches us a lesson learned, but only for those who have learned from it. When you do as you please, you live a precarious life, which in return brings more chaos in your life, fueled by Satan and the people around you in this world who do not wish for you to or care if you succeed in your endeavors. As a reminder, happiness is never guaranteed to anyone. But doing your best in this world by following God's Word will be smiled upon by your heavenly Father.

Life is not an easy road to follow, especially when the chips are stacked against you. Everyone does not even start out with the same amount of chips. This life we live does not count the chips you have or

don't have when you come into this world; it only counts how well you use the chips when traveling down the road of life. There will always be people with more of whatever you do not have. So do not envy them but, rather, strive to do the best with what you have been given, for this is where you can show your strength as a child of God. God will give you the strength you need every day if only you should ask him. No one is strong enough to live this life without God's help.

Now that being said, I do believe Satan helps his children too. So the choices we make in life are our own, not God's. Since he gives us that freedom, some of the people we meet in life won't always be on the same page as we are. But do not fear, for if you follow the Word of God, you will be covered in his grace. As you live your life, do as God has asked of you, and all will be clear in the steps you take. Just be strong.

Life deals us all a different hand, and what transpires from the hand we're dealt is our perception of these things affecting our lives. Each day is different, unknown, strange, and surprising in its effects on our psyche. What God has asked of us is unchanging, consistent, reliable, and true; and, most of all, it is forever pure in nature. God has asked only of us that which is pure in nature and clean in our heart. He does not demand anything that we, as his children, do not possess. You would not possess these attributes if your soul was dark and void of his Word. God will remove any uncleanness from your heart and soul with faith, love, and hope in his Word in your daily prayers.

When you have God on your side, all things are possible, and you are able to live a good and blessed life. Some people believe that a blessed life is a life without problems. But remember, you do not live in this world alone; everyone is free to make their own choices, and choices have consequence. You have to be accountable for your actions, for your actions affect those around you. Just try living your life one day at a time with thankfulness and empathy for others.

"The desire of the righteous is only good: But the expectation of the wicked is wrath" (Proverbs 11:22–23). Open up your mind and heart to learning God's word and see the difference in your life as you live it. Things will not necessarily become easier but will be more understandable as you deal with everyday situations.

Not to get too far off the road of pagan beliefs, just remember that our beliefs can take us far off the road. We can be led into a danger zone that looks real but is frothing with worldly temptations that appear normal because they have been practiced for so long. When you examine pagan beliefs and how each started, ask yourself, Is this what God has asked of me in his word in the Bible? Is this his intentions for his children to honor and obey him? Only if you read the Bible will you know the answers. When you pray for understanding of God's Word before you read his Word, you'll still not always completely understand. But with help from a study Bible and by living your life in earnest faith in God's Word, you will surely see your way to a better life—following the path that has been laid out for a child of God.

If it appears that I repeat myself a lot, it is because I do. God's Word to his children is true and unrelenting in every aspect of our daily living. What holds true in biblical times still hold true now. People have not changed; only the times we live in are different. Ancient times are a mirror to our past, not a way that has led people to live and love down a better path. Things have changed without changing, for we still want things we desire without understanding the full consequences of our wants in life.

Know that, when you are a child, you follow the belief of your parents and what you're taught as a student in school. But as an adult, you have the right to question the beliefs or teachings of your youth, because this is a life that you are responsible for. And you cannot pass along a belief without investigating how it came about. Know the truth, and the truth shall set you free. If you still have the same beliefs, then it is not the lack of knowledge that keeps you going down the path you choose; it's your desire to live the worldly life that has kept you on the same path as that followed by generations before you.

When you attempt to lead the life that God has asked of you, and you pray for his help and guidance, only then will you see the lighted path he has laid before you. We all have free will. It's your choice to live as you please within the law. The law cuts both ways. You can live in this world without living as the worldly ways suggest we should. Your way of living is your choice. The lighted path is protected by God's Word; the unlit path is not

If nothing else, study how all these traditions came about, and you will see firsthand that God would never condone such traditions. When and if you do your research, you will find that the things we celebrate and the traditions we have we created are for ourselves, not God. The thing he has asked of us is written as his Word. Follow how Jesus lived his life. He told us in his teachings the things he wanted us to obey, celebrate, and honor. No pagan beliefs were mentioned. We have brought these things into the world for our own satisfaction, not his.

Like I have always said, life is simple; people make it hard. Read your bible.

Chapter 5

True Believers of God

True believers of God live by his Word, not by the words taught by the worldly people who think they are honoring him by way of pagan beliefs. The Lord has explained to us in the Bible what he has asked of us to honor his name, and it does not cover false worship of pagan beliefs. To live the life God has put forth for us is a simple task. Our wants are what drag us down to despair at times. But what God has asked of us is a simple path, easy to follow, which keeps our lives in perspective, humble and unashamed. We are the ones who choose the rugged road to walk down when we make the wrong decision in life, instead of following God's Word. Your life becomes a struggle when you follow the wrong path but is enlightened when you follow the Word of God and things are kept in the right perspective. Like I've said, life is not hard. We make it hard. And sometimes, the company we keep makes it that way (1 John 5:20–21). Paganism reaches far into our lives if we let it. Believe what God teaches us, not what man says, for, intentionally or unintentionally, people will lead you down a wrong path that doesn't honor God. Just follow the right path in God's Word only.

When we live our lives with the perspective of what God teaches us in his Word, we learn the way. We see the lighted path that the Lord has laid out for us in order to steer us clear from stumbling through our way in life. Sometimes we inadvertently put our own stumbling blocks in our path, and sometimes a block comes by way of just listening to people

we trust in. Follow God's Word, and there won't be any confusion. Listening to the worldly way can have a harmful influence on our daily life when keeping up with the worldly way of living like others are doing. Have faith in God. The wisdom is in God, not in the worldly way of men today. God's Word is the only way to salvation, the only way to lead your life in a way of pleasing God. I do believe that, when people read and trust in the Word of God, their lives are less stressful and they have more understanding of life's and the ups and downs. His words calm you and give you understanding of how you should handle whatever comes your way. This may not give you the quick gratification you seek. But in the long run, it gives you the peace you need to sustain your inner soul and harmony of mind and body.

True believers of God will trust his every Word, even if they're unsure how things will turn out, because some things do not turn out the way we expect them too. Some things are for the best even though we cannot see this at the time. Remember that everything happens for a reason. Life goes in a circle, and bad karma will return if you don't watch your step. When we ask for God's help in going in the right direction, we should follow his advice and his advice alone. Most people like to follow their instincts or the advice of others. Follow God's advice It is all in the Bible—everything you need to know.

People have not changed; only the times have changed. Some are weak; some are strong. We all have our burdens to bear. But God will give us the strength to carry on in the right direction if we follow his Word and ask him for directions when we're unsure of the steps we should take. "My defense is of God, which saveth the upright in heart, God judgeth the righteous, and God is angry with the wicked every day. If he turns not, he will whet his sword; He hath bent his bow, and made it ready. He hath also prepared for him the instruments of death; He ordaineth his arrows against the persecutors" (Psalm 7 10–13). Apply your life to God's Word, and you shall be free from unnecessary burdens.

Do as God asked and you will be the stronger for it. When you exercise your mind and body, your muscles in your body and the knowledge in your brain become stronger for it. Exercise your spirit in God's Word and you will become stronger for it. We fail, we have flaws,

but we pick ourselves up and keep trying every day, and this is what keeps us closer to God.

Make room for prayer when you get up in the morning, during the day, and before bed at night. Anytime is a good time to thank God for his guidance and everlasting love. His generosity, peace, and kindness bring us closer to him. Your perseverance will give you love, faith, and hope in your daily living.

Do as God asked and you will be a better for it. Do not follow the worldly way; it is misleading in so many ways and has been for a very, very long time. When you don't follow his Word, you go blindly onto the path of the ones who lead you, not the path God has laid before you in his Word. Just because everyone is doing something does not always make it right. Always ask the question, is this what God wants from me. Commonsense questions, believe it or not, aren't always easy for some people. Some people are smart but aren't born with common sense when it comes to how to do unto others as they would have others do unto them—not even for the scholarly does everyone have the same understanding about life's journey.

When you read your Bible, you will understand why you should follow his words and not the word of the worldly. People love to fit in and not feel different from others. Fitting in with others and not going against the grain of life gives people the feeling of belonging. The problem with that is, as you know, you can't have two masters. Either you are a child of God, or you are a follower of Satan. You can't be lukewarm in your service to God and what he teaches us in the Bible to do and not do. We, as humans, do often make mistakes. But we can always strive to do our best with the days God grants us and pray for his strength in guidance. We do nothing on our own; everything we do, from waking up in the morning to going to bed at night, and all that happens in between, is because of his mercy, his love, and his forgiveness of our sins—which carry us throughout our lives.

To believe in his Word will give you so much comfort right now here on earth that your eyes will be opened. When you do as God asks you, you will see how simple life can be. People make their lives difficult, not God. You can have wants and needs without being materialistic or greedy. These feelings are normal but not a prerequisite to life. Think

about what you desire and the benefit or consequence of having it. Does it benefit or weaken you in your life's journey?

As the Bible tells us:

> Whence then cometh wisdom? And where is the place of understanding? Seeing it is hid from the eyes of all living, and kept close from the fowls of the air. Destruction and death say, we have heard the fame thereof with our ears. God understandeth the way thereof and he knoweth the place thereof. For He looketh to the ends of the earth, and seeth under the whole heaven; to make the weight for the winds; and he weigheth the waters by measure. When he made a decree for the rain, and a way for the lighting of the thunder: Then did he see it, yea, and searched it out. And unto man he said Behold, the fear of the Lord, that is wisdom; and to depart from evil is understanding. (Job 28:20–28)

Through God's wisdom by reading and studying his Word we will understand his words in the Bible. We have to study the Word of God to have the knowledge that he wants us to have. To believe in him is good, but to have faith in his Word is even better. When you have faith in God and trust in his Word, then you are enlightened and living in the light and not the darkness in this world. The load of the burdens you carry everyday will lessen.

True believers of God follow his commandments and live by his teachings. Even when you falter, you can try and try again. We are not perfect humans. We can understand things differently from one another, and we learn things at our own pace. Only in strength, patience, and prayer can we tackle the day head-on. Live your life through prayer and reading your Bible to gain the understanding of what God expects of you.

No day is the same, and each day is a story of its own. Tackle each day with prayer, because only God can get you through it. Never believe that you are getting through this life on your own strength. Each soul has their own burdens to bear, and some fair better than others. God sees in each one of us what we can and can't do. That is the glory of being a child of

God. All you have to do is ask, and you will receive. But understand that God knows what you need even before you ask, and he will grant it when he knows you deserve it. This doesn't mean he'll give you what you want when you want it; this is not always the case. When you read the Bible, you'll note that some people had to wait a mighty long time for the things they wanted and had waited for many years for what they'd hoped for to happen in their lives. True believers of God know that he knows what we need, but in prayer, we pray for help, guidance, and the assurance that we can carry on, knowing his love will protect us in our daily lives.

True believers are given the strength and courage through faith and prayer to carry on with their life without the crutches that some people grab hold of. God gives us what we need. We just need to believe in him:

> Therefore, being justified by faith, we have peace with God through our Lord Jesus Christ; by whom also we have access by faith into this grace wherein we stand, and rejoice in hope of the glory of God. And not only so, but we glory in tribulations also: knowing that tribulation worketh patience; and patience, experience; and experience, hope: And hope maketh not ashamed; because the love of God is shed abroad in our hearts by the Holy Ghost which is given unto us. For when we were yet without strength, in due time Christ died for the ungodly. For scarcely for a righteous man will one die: yet peradventure for a good man some would even dare to die. But God commandeth his love toward us, in that, while we were yet sinners, Christ died for us. Much more then, being now justified by his blood, we shall be saved from wrath through him. For if, when we were enemies, we were reconciled, we shall be saved by his life. And not only so, but we also joy in God through our Lord Jesus Christ, by whom we have now received the atonement (Romans 5:1–11)

My heart is at peace, and my soul is secure with the love of God as my guiding light in this world that I live in. True believers live in

harmony with our Lord and Savior and fear not their future. Faith leads to harmony and understanding of what God expects of us, which, in return, will bring peace to your life. It's as simple as that. Have faith in all your endeavors and trust that, when you pray for guidance on your path in life, God will steer you in the right direction for you. Just ask and you shall receive, and what you receive and when you receive will be right at that time for you.

You should be guided by God, not the worldly mass of people who can't save one hair on your head, much less your soul. Again I say, read the Bible. The answers are there. See what holidays are special days God asked us to remember or celebrate or honor in our lives on earth. You will see that there aren't many at all. We've created all the mass confusion and pagan beliefs ourselves to satisfy our own false hopes and dreams. God did not ask these things of us. Think of all the money people spend on futile beliefs and of the unhappiness of people who do not have the money to spend on these days. Life is about God, not material belongings that collect dust.

Things are not always as they appear to be. When you can buy all that you want, your needs take second place in your life. And in the end, you are not as happy as you thought you would be. The more you have, the more you have to watch over, secure, clean, and protect from the elements. This is a job you'll have as long as you keep a materialistic mindset, and as you probably know, you can't take it with you.

True believers in God know that those who practice materialism, those who follow pagan celebrations, and those who just follow others with no knowledge of why they're doing what they're doing have a slender chance of getting through the gates of heaven. Which is more important to follow—the Word of God or the way of the world? When you pray to God for guidance in your life, life doesn't get easier, but it does become simpler in terms of how you handle the day-to-day job of living on earth as we know it. Faith can carry you a multitude of miles in your everyday living and ease the pain of not knowing what's next. "Forever, O Lord, thy word is settled in heaven, Thy faithfulness is unto all generations; Thou hast established the earth, and it abideth. They continue this day according to thine ordinances: For all are thy servants" (Psalm 119:89–91).Just trust and have faith in the Lord. He has your back.

If you are a true believer of God's Word, would you not follow his Word? How can you follow the worldly way of living when God has laid out his plan for us? You have a choice. So are you following what the Lord is teaching us or what the world teaches us? Ask yourself these questions. Your soul is at risk here. Do you prefer to just fit in with society's way of living? Or do you prefer to be a true believer in God's plans for his children? You do have this choice. God always give his children a choice. Whatever choice you make is yours to make and live with.

Think about the choices you've made in life. Remember the ones you made with the guidance of God and the ones you made with your own guidance; notice how these choices panned out. God never leads us in the wrong directions. But our desire to do it our own way leads us in a circle of ups and downs we find ourselves in a cycle of despair when we try to live our lives without God in this world. We want things so badly that we're willing to do it our way and not God's way, pushing for it to happen in our own time. Getting what we want that way doesn't mean it was always a blessing from God; rather, something we pushed for may be a wish God granted that we will pay the consequences for. In the long run, choices made by you alone will have a different outcome from choices you make through prayer to God

Follow God's direction for the path you should follow. And do not be impatient. You'll notice that, in the Bible, some people did have to wait a long time for their prayers to be answered. They did not lose their faith in God, even if they became weary at times. They never lost faith. Do not be pushed by Satan or anyone you love to do something you do not believe in, for you will pay for it in the long run every day of your life. If you are a true believer of God's Word, you will follow his Word without worry about ridicule from others. You can do this by reading and understanding his Word. Read the Bible over and over again; pray for true understanding. This will help you to understand what he wants from you. If you prefer to wing it on your own because you don't believe in God or you just don't want to read the Bible. Then you will be taking chances with your own salvation.

Whatever your instincts are telling you, remember that God loves you and will never lead you down the wrong path. But people will lead you astray to get what they want. Satan will mislead you to get what he

wants. Only God's love for you will give you eternal life when you follow his Word; neither the guidance of man nor that of Satan can do this for you. Whose hands do you want to put your life in? As humans, we are not perfect. But like I said, we do have choices.

True believers in God take responsibility for their lives here on earth. They understand God's will. They don't ascribe to man's willingness to live a selfish existence. And what I mean by this is to know better, but not trying to do better. Just because you think you might hurt a family member or friend's feelings. Some people cannot see the worth in their lives without the assurance of others or appear to be different than most. Some people will never be strong enough to fight the fight over being a strong believer in God or being a strong believer in the worldly existence of humankind. When you choose a path in life, you do not have to stick with it if you find it to be the wrong path to take. Do not surrender your life to a way that leads you on a dangerous route, even if that path makes you feel comfortable around others. Be strong and be a child of God following his Word.

When Judgment Day comes, will you have excuses or weaknesses that you think that you can fall back on or you'll just play ignorant and say I didn't know these teachings of God's Word." Only a child of a young age can profess such ignorance. We are accountable for our beliefs, our way of living, and what we teach our children. Sometimes we love people so much we just want them to be happy but leave them with false doctrine.

Again I say, read your Bible. And the truth will set you free from the bondage of living a false life that will lead you and your loved ones on a false journey in life. Everything has already been written down, tested, and tried. We just need to listen. And you can if you are a believer of God. Study history and how all these beliefs came about. And soon, you will find out that paganism and the worldly beliefs of humankind have shown up throughout our lives and penetrated so deeply into our souls that some people cannot turn around and go back to God. They are steeped in pagan practice, and they like it. "Everyone does it," they say. "What's the harm in it? It makes me happy, it makes the children happy. It makes people in general happy."

God knows best. He knows the outcome of things we do or say before we do or say them. Having peace, love, faith, and hope in your life can make you happy also—without the big price tag to pay. Honor God by believing in him because all the glitz and glamour does not honor him. God is happy when his children follow his Word. If you want to follow something or someone, find out about the truth of it. It is much easier to dump Satan out of your life than you think. If you do so, life's load will be so much lighter to carry here on earth.

True believers of God are his advocates:

> My little children, these things write I unto you, that ye sin not. And if any man sin, we have an advocate with the Father, Jesus Christ the righteous: And he is the propitiation for our sins: and not for ours only, but also for the sins of the whole world. And hereby we do know that we know him, if we keep his commandments. He that saith, I know him, and keepeth not his commandments, is a liar, and the truth is not in him. But whoso keepeth his word, in him verily is the love of God perfected: hereby know that we that we are in him. He that saith he abideth in him ought himself also so to walk, even as he walked. Brethren, I write no new commandments unto you, but an old commandment which ye had from the beginning. The old commandment is the word which ye have heard from the beginning. Again, a new commandment I write unto you, which thing is true in him and in you: because the darkness is past, and the true light now shineth. He that saith he is in the light, and hateth his brother, is in darkness even until now. He that loveth his brother abideth in the light, and there is none occasion of stumbling in him. But he that hateth his brother is in darkness, and walketh in darkness, and knoweth not whither he goeth, because that blindness hath blinded his eyes. (1 John:1–11).

There are so many choices in your life to make. How can you be sure you are making the right ones? Do you care if you make the right ones? It is your life, right? It's your life, which God gave you, and his son's life— his son who was crucified for you. Do you not owe him some obedience, love, and respect? When we are children, we can say we did not know, and people will understand. We are young and impressionable and need to find our way in life. But there comes a time when we should grow up and learn what God expects of us and learn his Word to us.

What I'm saying is you have a choice. You can read the Bible and learn to honor him in the way he has asked of you, or you can follow the world in ways and traditions that please you but don't necessarily please God. Do not follow my beliefs and understanding. Ask God in prayer to give you understanding as you read your Bible. When you do your research, you will find out from ancient history, as well as history from not too many decades ago, how all these traditional beliefs came about. You'll see how we've been led down a long and winding road of glitter and gold with no substance; but it all looks so pretty, so bright.

If someone gave you $5 million, you would be very happy, right? But would you be happy if you were told it was stolen money? I think not. Think about what you are doing and who you are hurting. Think about who is not please by it. And then make your choice. "And he said unto them, Full well ye reject the commandment of God, that ye may keep your own tradition" (Mark 7:9).

Conclusion

Paganism is a deeply emotionally-burdened subject matter that creates mixed feelings for different people, religions, cultures, and beliefs. This is because each person has grown accustomed to the pagan practices thread within their life's journey. Judge not the beliefs of others, whether you participate or abstain from participating. Do honor unto God by what he has taught us to do in his Word.

Which will you choose: God's will, or the choices we make in life? Know the difference between the two. Your journey will show you different pathways to take while living on earth, and each person has their own perception of which direction to follow—which pathway to walk down. Each Christian has their own approach to cultural beliefs that have become prevalent today.

For me, an understanding of how our beliefs have come into play over the centuries has been refreshing and relaxing and has helped in the rebuilding of my soul.

Enlighten yourself by studying God's Word, for the truth shall free you from the burdens of the world. All days are to be dedicated to God through holy living and godly services. Every day should be highly regarded on your journey in life.

Poem

The People of the World

The people of the world cried out to the Lord and said,
"Dear Lord, should we have faith in thee?"
And the Lord said, "Yes, I am the truth, light, and the way.
Having faith in me will set your mind, body, and soul free."

The people of the world cried out to the Lord and said,
"Dear Lord, can there be peace in the world?"
And the Lord said, "Yes, for peace is within
the believers who have faith in me."

The people of the world cried out to the Lord and said, "Dear
Lord, can there be love in the world for one another?"
And the Lord said, "Yes, for love is within those who love me,
for they have peace in their hearts and can love one another."

And the people of the world cried out to the Lord and
said, "Dear Lord, can there be hope in the world?"
And the Lord said, "Yes, for hope dwells in the hearts
of those who are believers in me, for they are believers
in faith, peace, love, and hope in my Word."

—Lillie Sandridge-Hill

References and Research History

In *Paganism Dressed up in Christian Clothing*, Lorraine Day, MD, writes, "To attract the Christians, Roman Emperor Constantine gave the holidays and festivals that were celebrated by the Pagans Christian's names and identities, thus appeasing the Christian over the centuries. This practice has continued until the present time when we find two systems, Paganism and Christianity almost indistinguishable. This is the adversary's clever deception. Paganism dressed up in Christian clothing. It's still nothing more than Paganism, but Christian churches have wholeheartedly embraced the deception."

Research the history behind Christmas, Easter, Halloween, and Valentine's Day, along with many other holidays we celebrate in this world, and you'll see how each came about and how they were represented in the societies they were started in. We should honor what God has asked us to honor: his commandments, not pagan traditions. Read your Bible and do your research. Find the truth, for the truth shall set you free from condemnation. Step away from the traditions that lead you into a bottomless pit. "And ye shall know the truth, and the truth shall make you free" (John 8:32).

Our beliefs should be in the roots of our worship in the scriptures, rather than paganism. God tells us not to learn the ways of the heathens for God condemns these practices and so should we.

References

Fletcher, Richard. *The Barbarian Conversion: From Paganism to Christianity*. New York: University of California, 1911.

McMullan, Ramsay. (1984) *Christianizing the Roman Empire A.D. 100–400*, Yale University Press, p. 90.

Further reading

Angus, Samuel. *The Mystery Religions and Christianity*. New York: University Books, 1966, 359.

Biblical references

Exodus 32:4–5, 7, 10, 11–14
Deuteronomy 12:29–31
1 Corinthians 10:19–22, 25
Acts 15:29
Romans 14:1–8, 5–13
Matthew 15:13–14

Printed in the United States
By Bookmasters